Adult Coloring Book
Butterfies
& Flowers

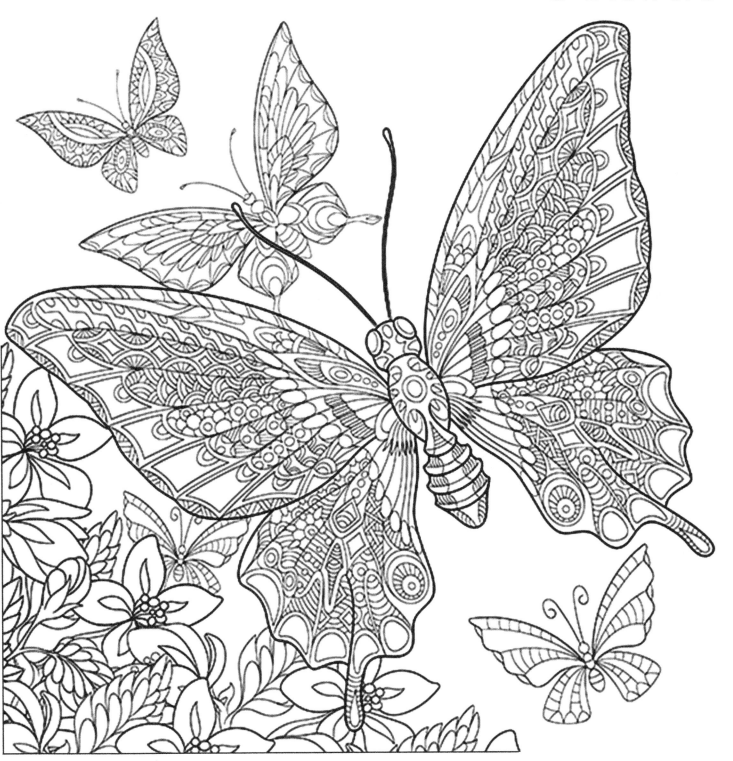

Adult Coloring Book:
Butterflies & Flowers

www.ArtandColorPress.com

ISBN: 978-1-947771-07-9

Printed in the U.S.A.

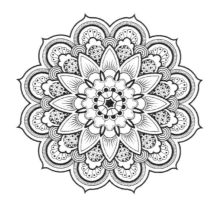

We believe that art enriches lives.

Art and Color Press is an independent publisher created to bring you unique books of beautiful designs to color, while helping to fund art education in our public schools. We donate our profits to foundations that provide art classes and needed materials to help students learn the joys of being creative.

Art can make a difference in everyone's life.

Each person at Art and Color Press has genuine life experience working in the arts. We are painters, illustrators, designers and animators. Now, creating adult coloring books is one of the ways we are giving back.

We are enthusiastic colorists ourselves, and have carefully created and curated the selection of designs on the following pages to bring you hours of enjoyment. Thank you for choosing this book!

Please help us spread the word!
Put a review on Amazon. Tell your friends.
Give coloring books as gifts.

How to use this book

Coloring is successful for everyone. From the beginner to the advanced colorist, everybody can make beautiful pictures. Coloring is relaxing because when we concentrate, the outside world falls away. Pressures and tensions fade the more we focus on the stroke of color and filling in the design.

Getting started

Find a quiet corner or clear a space on your favorite table. Lay out your pencils, gel pens and/or markers. Choose a design in the book and take a moment to study it.

Think about the colors you enjoy and choose the ones you'll use to start. Take three deep breaths. With each breath, feel distractions fall away. Following your breath will help you stay relaxed and focused.

- **One design per page:**

 Each design is on its own separate page, single-sided. When you're finished, it's easy to cut out the page of your artwork to frame or give as a gift.

- **Choosing a palette of colors:**

 Consider what kind of mood you want the design to have. Cheerful and upbeat: choose bright colors. Calm: go for a limited palette with harmonious colors.

 Whatever palette you choose, select the colors and test them out on a practice page to see if they please you.

 Many advanced colorists suggest limiting your palette to five to ten colors. Using lighter or darker shades of the same color will add variety to your designs.

- **Shading will keep your coloring from looking flat:**

 Shading individual shapes is an important technique. Use two or three lighter and darker shades of the same color, then blend them to create depth and dimension.

 Try outlining the shapes with darker shades, then blend towards lighter in the middle.

 Consider imagining a light source shining on the design, and make highlights of lighter colors where the light would be shining.

- **Trust your own imagination:**

 There is no right or wrong way to color. You have total freedom, and the fun of coloring includes experimenting with color combinations.

 These are your pages. You only need to please yourself!

Where to learn more:

You will find many helpful video tutorials about coloring techniques with pencils, pens, markers and pastels on our website: www.artandcolorpress.com. You can also search on YouTube for instructional videos. Thank you to the many talented artists for sharing their knowledge for everyone's benefit.

Test page for your colors

The smooth surface and bright white paper of this book are perfect for colored pencils, gel pens, markers and a variety of other media. Insert a blank piece of paper behind your working page to protect from bleed-through, if you are using colored markers.

Happy coloring!

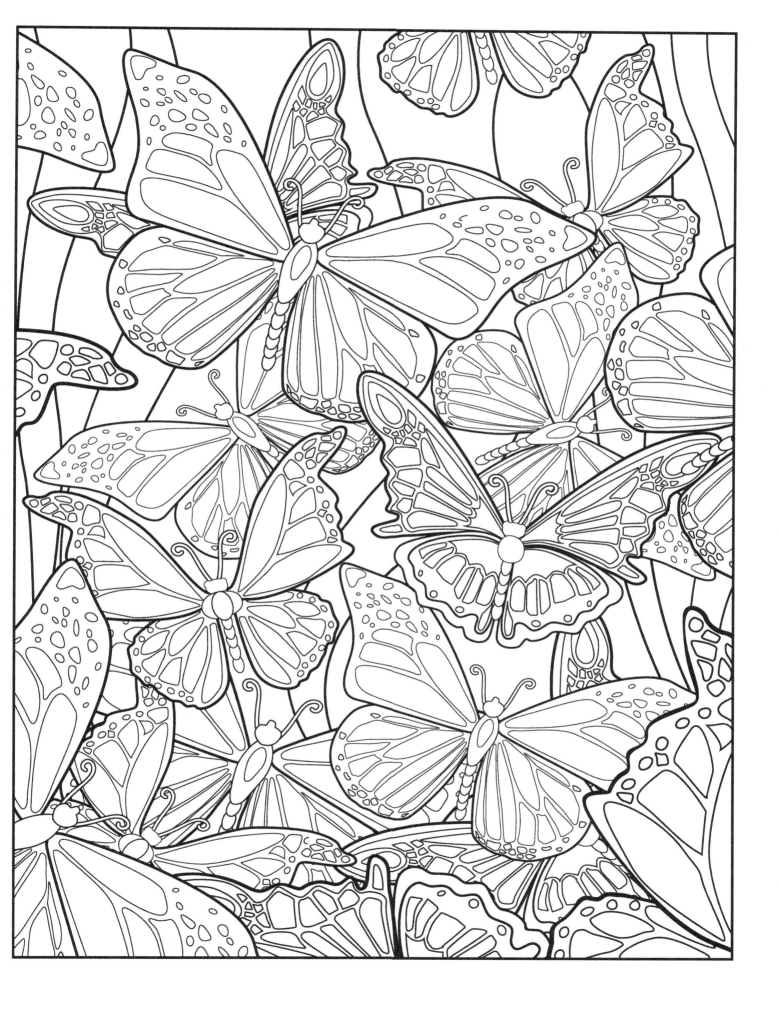

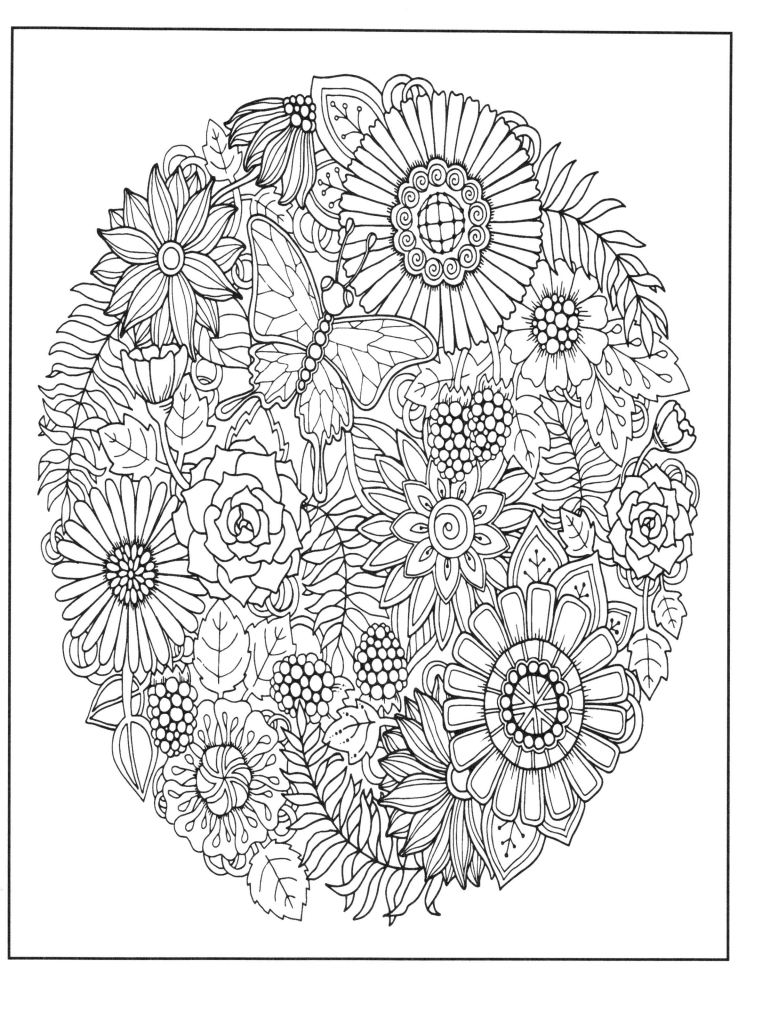

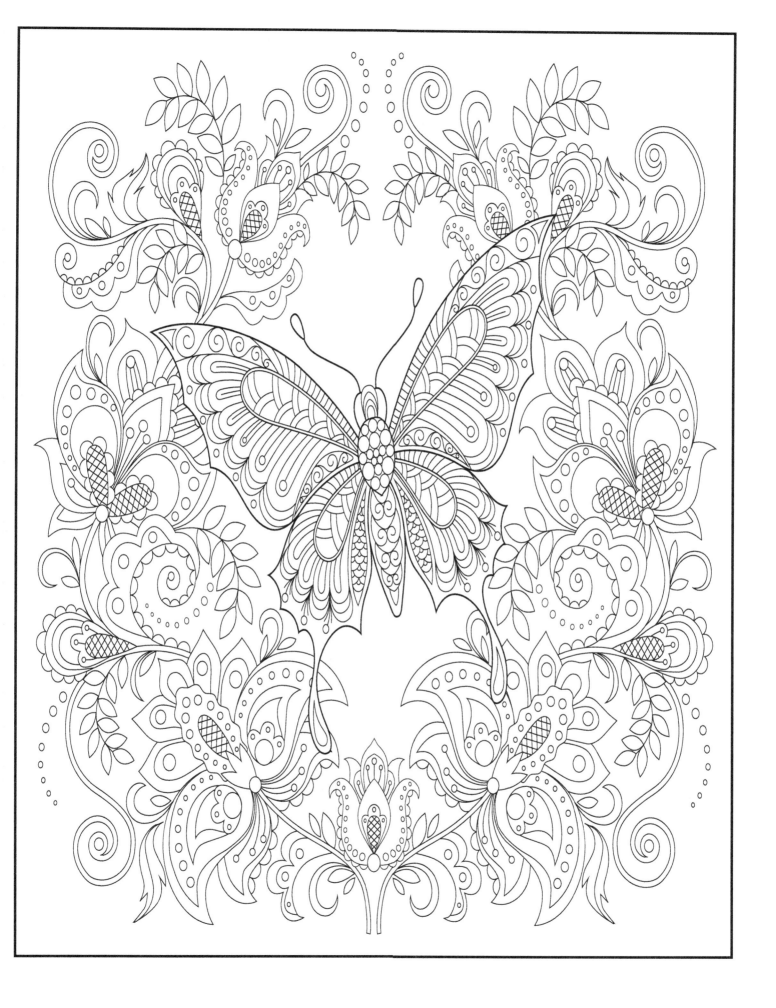

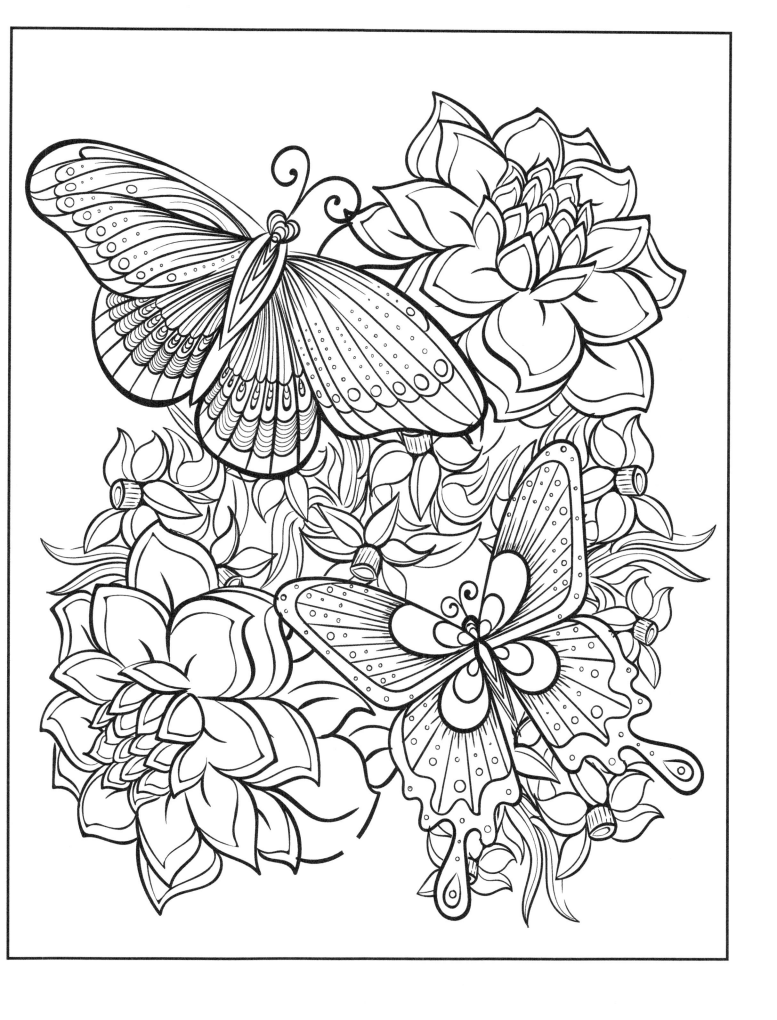

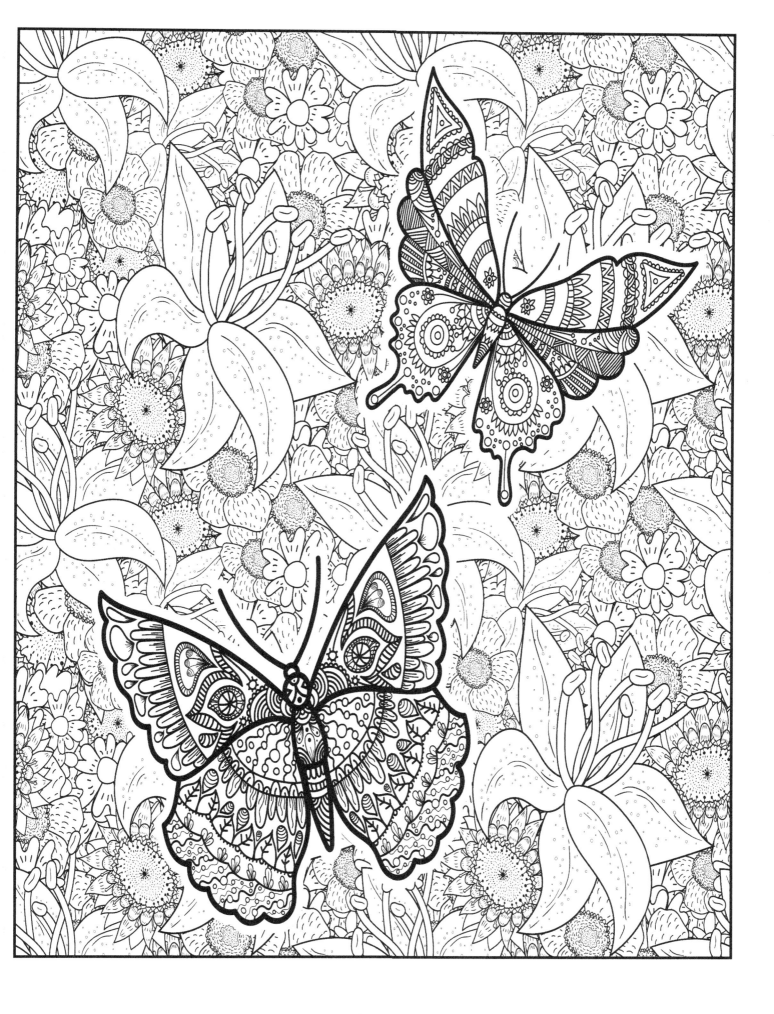

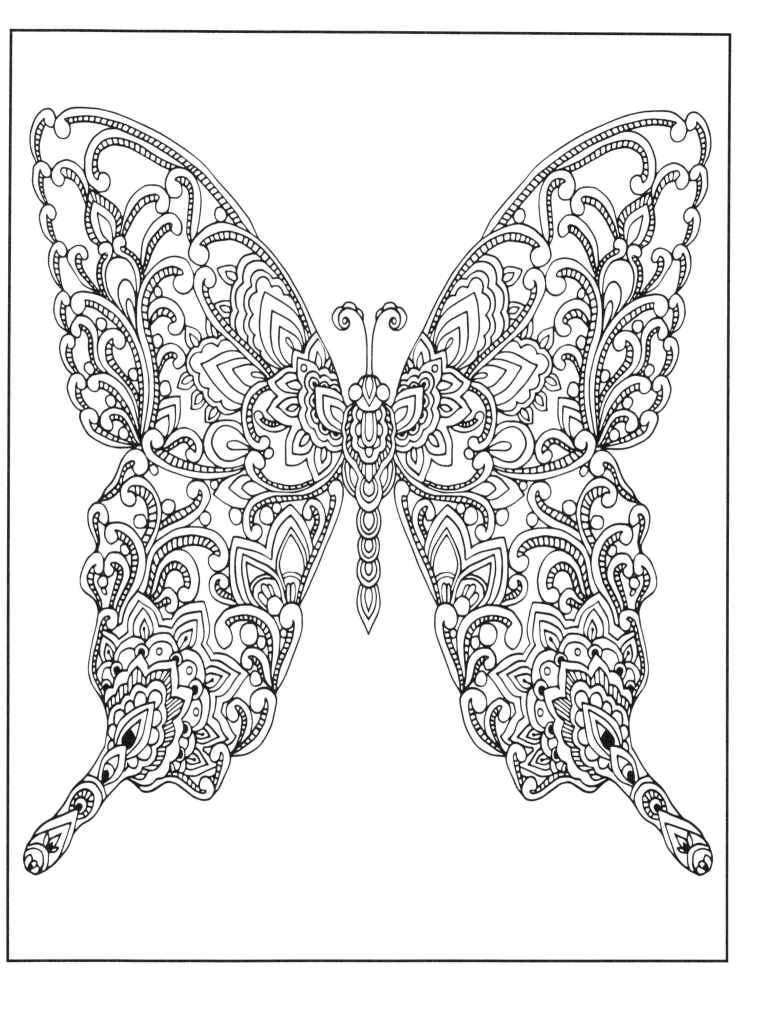

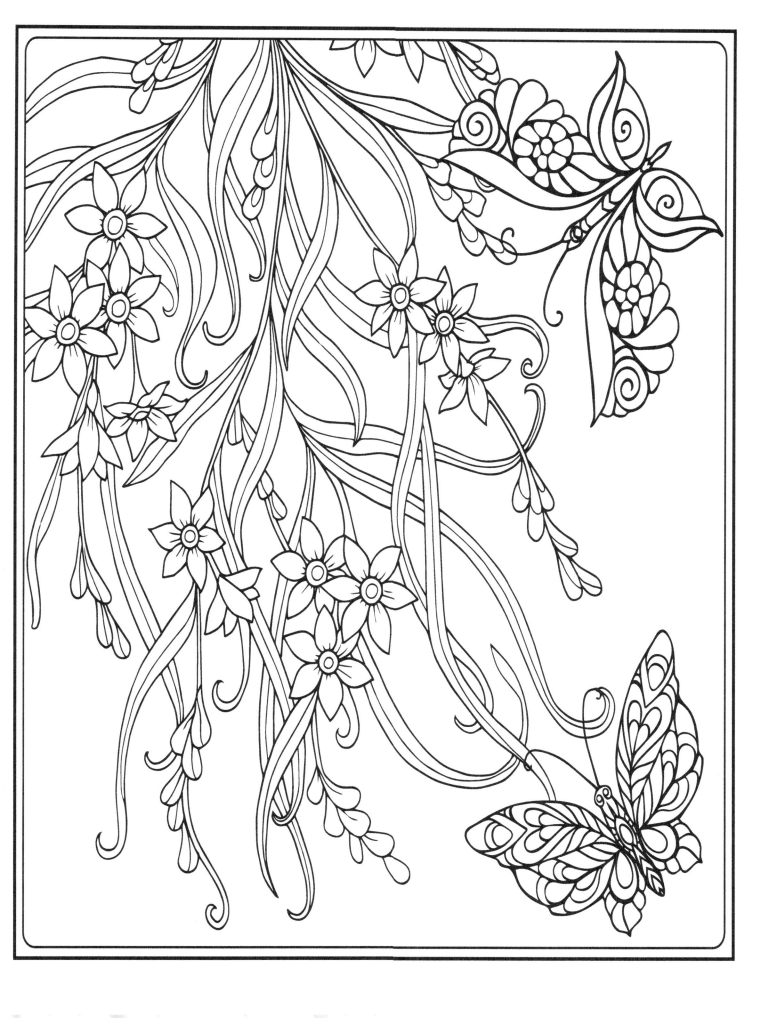

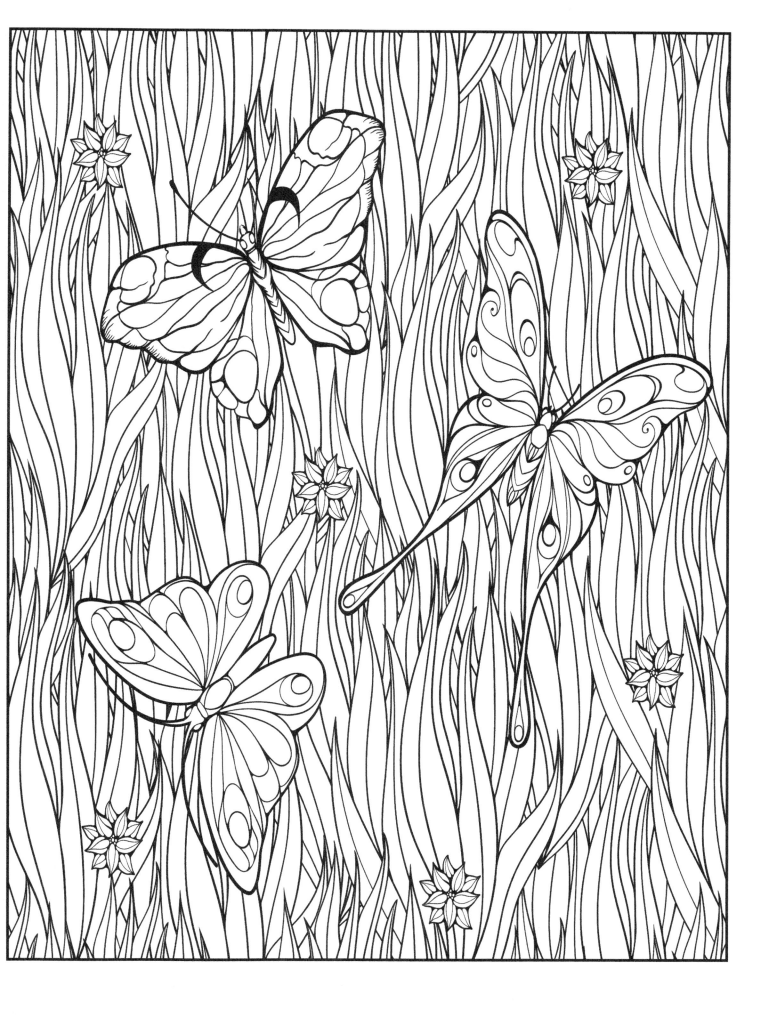

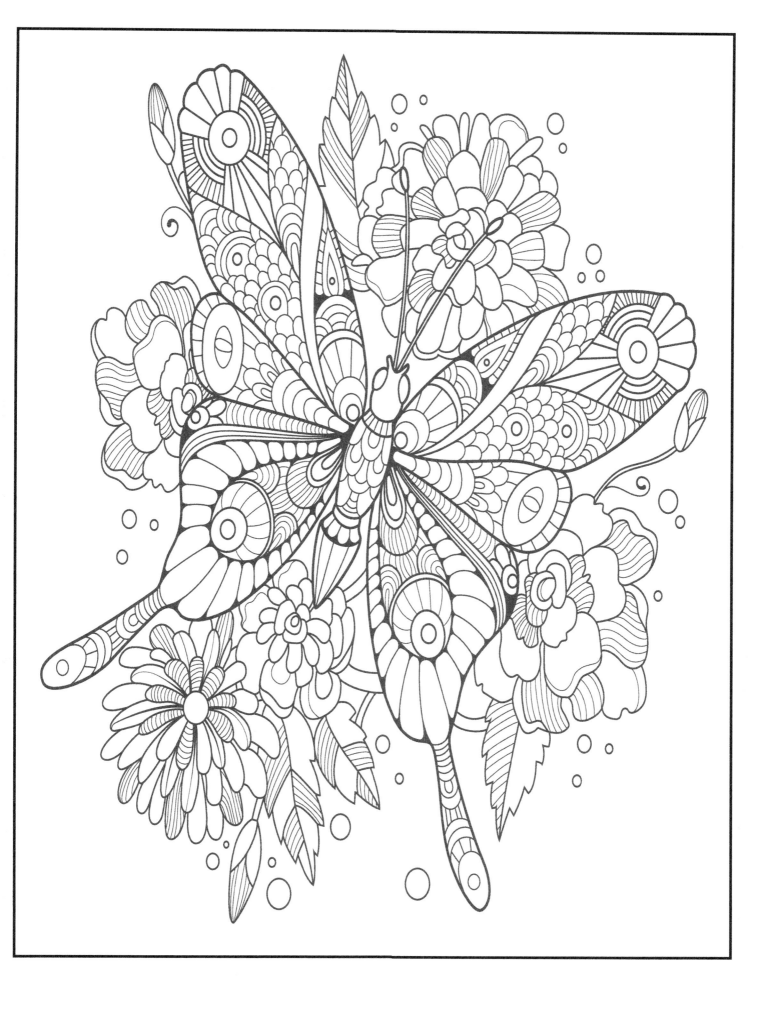

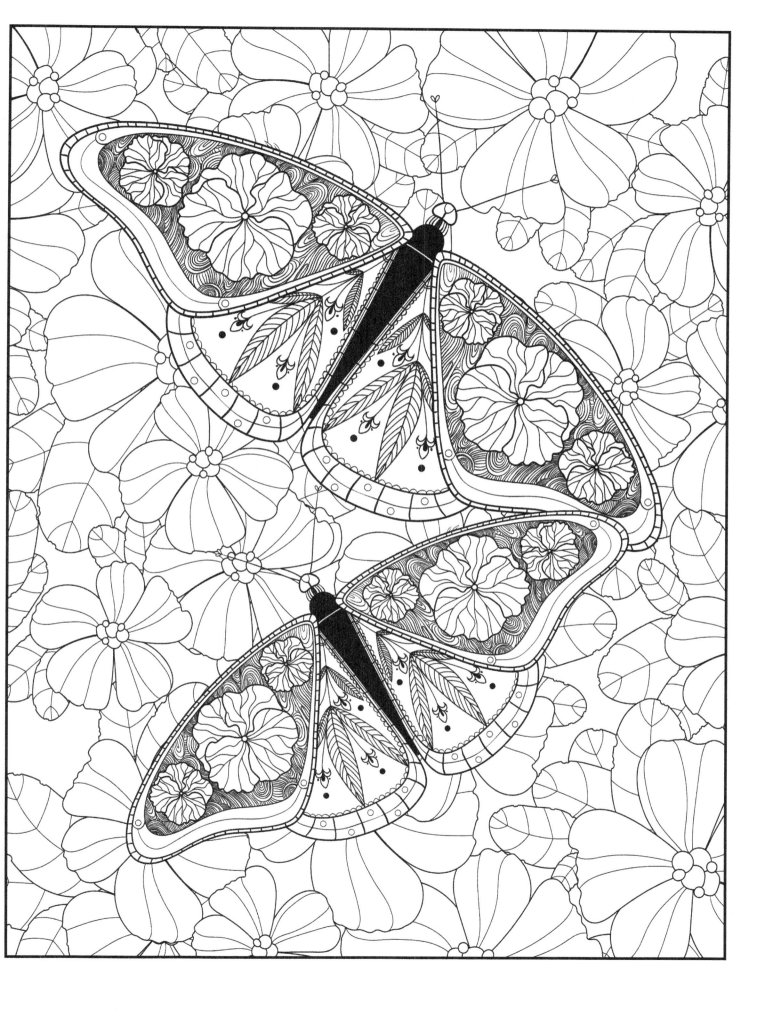

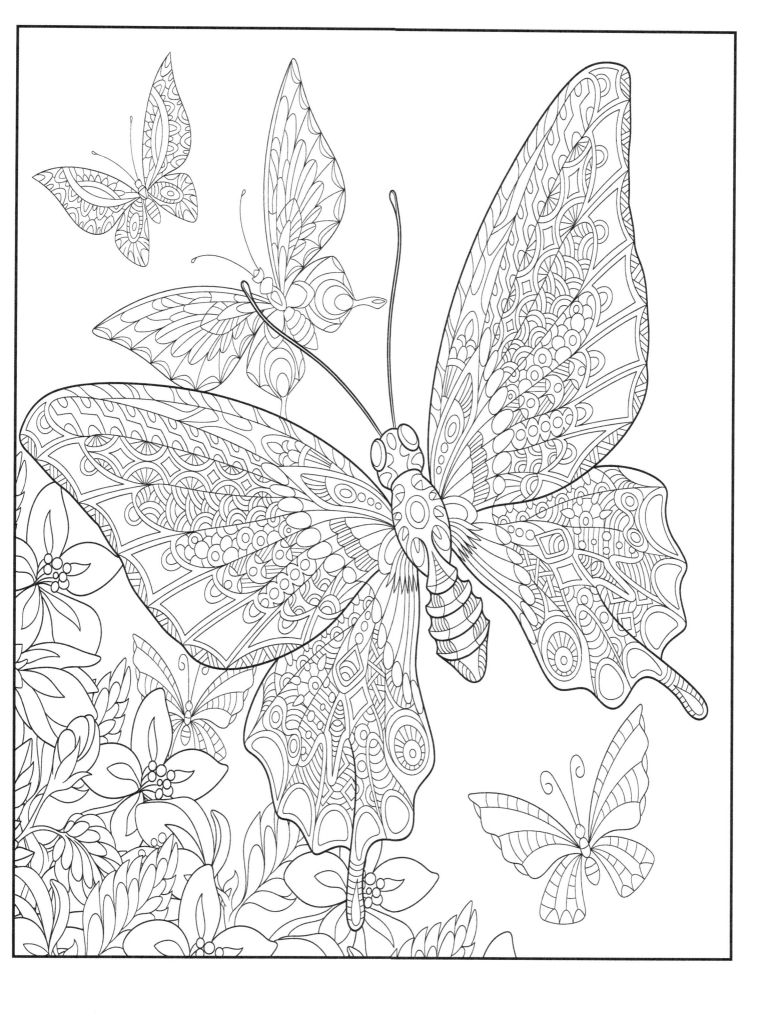

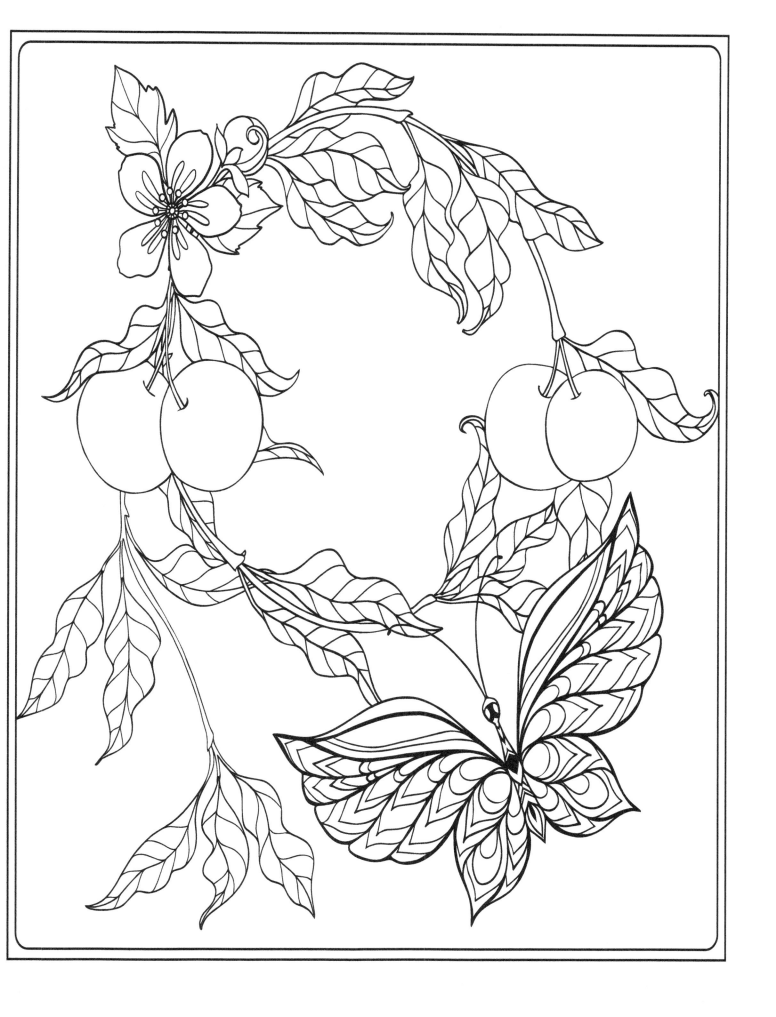

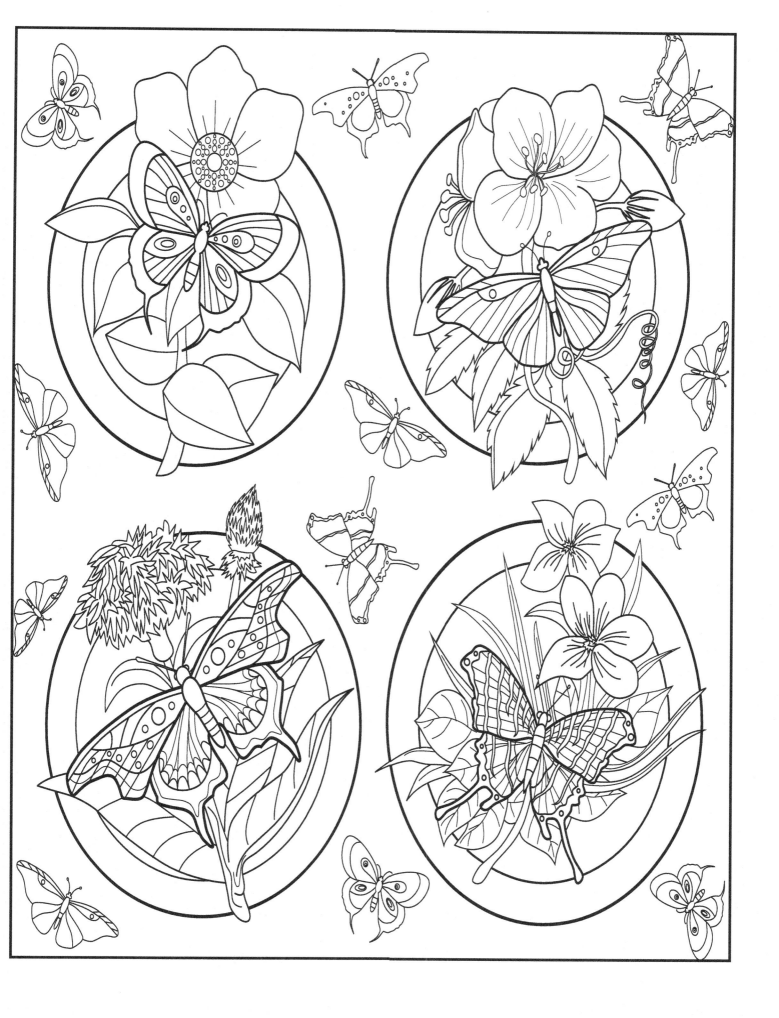

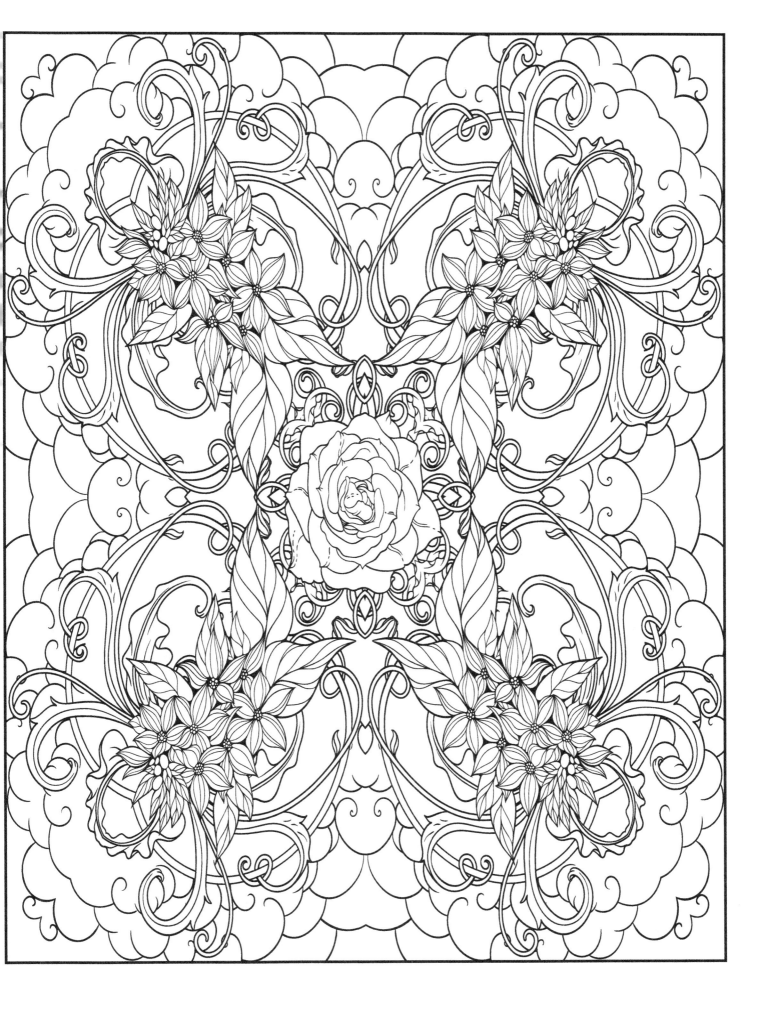

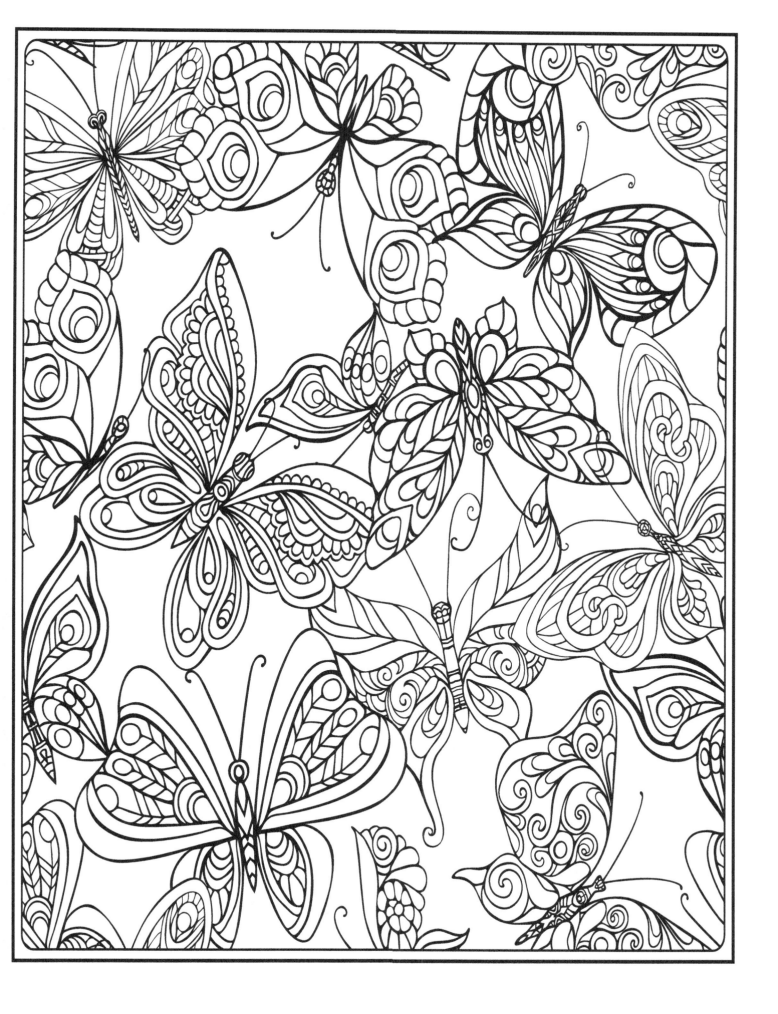

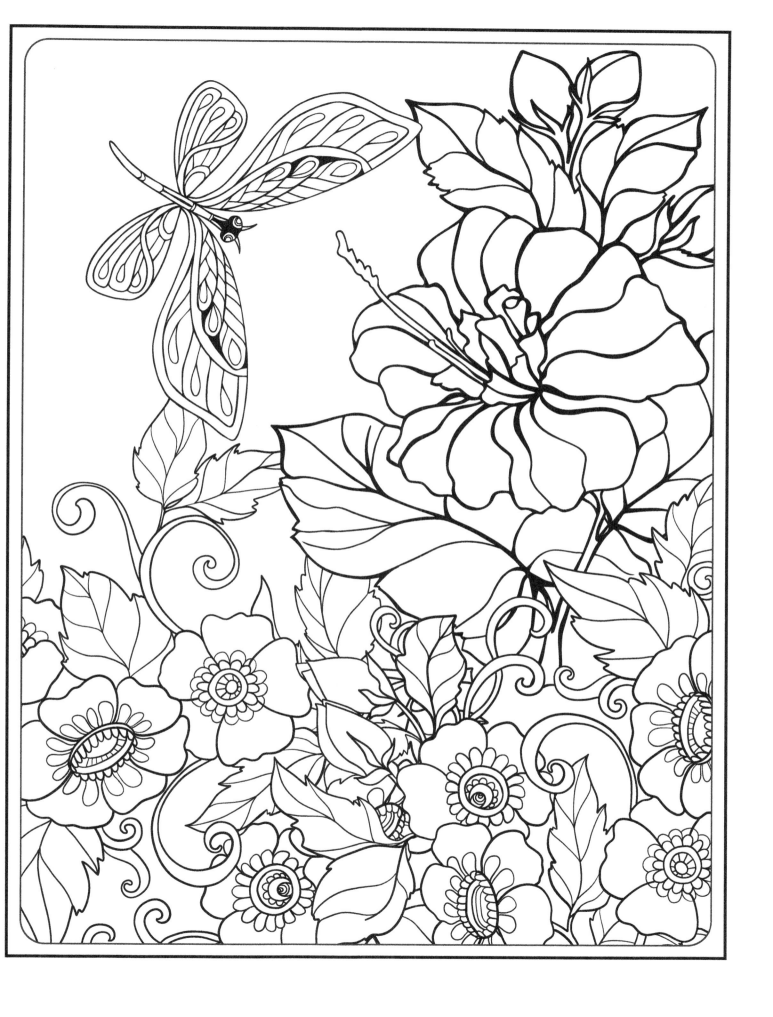

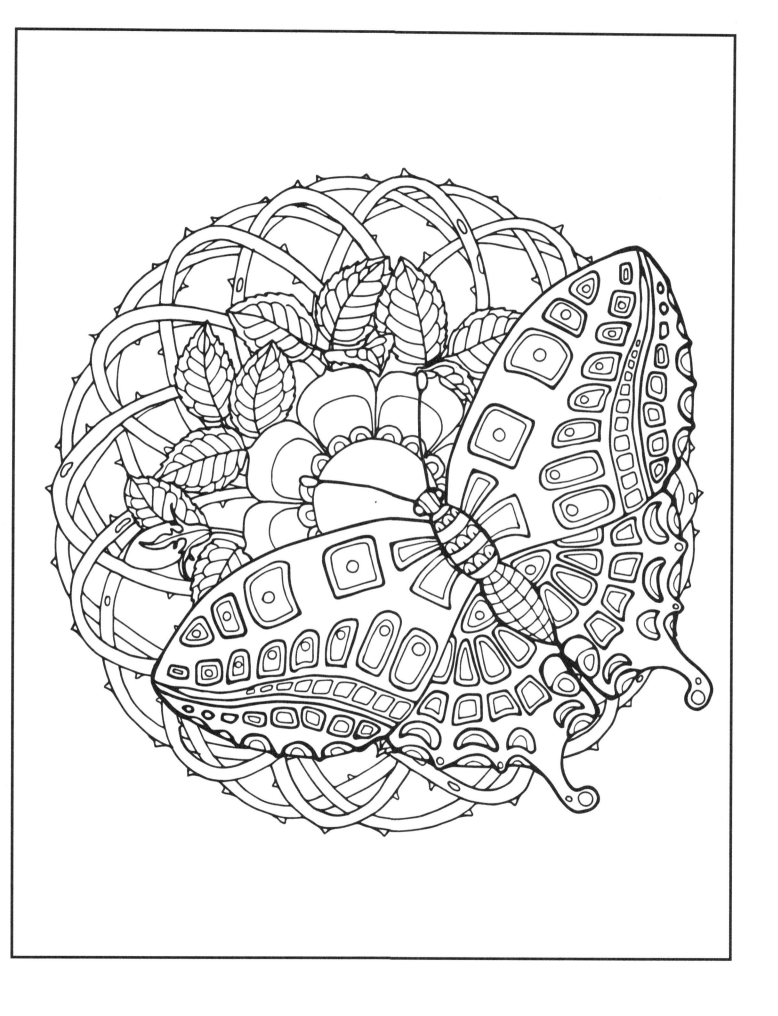

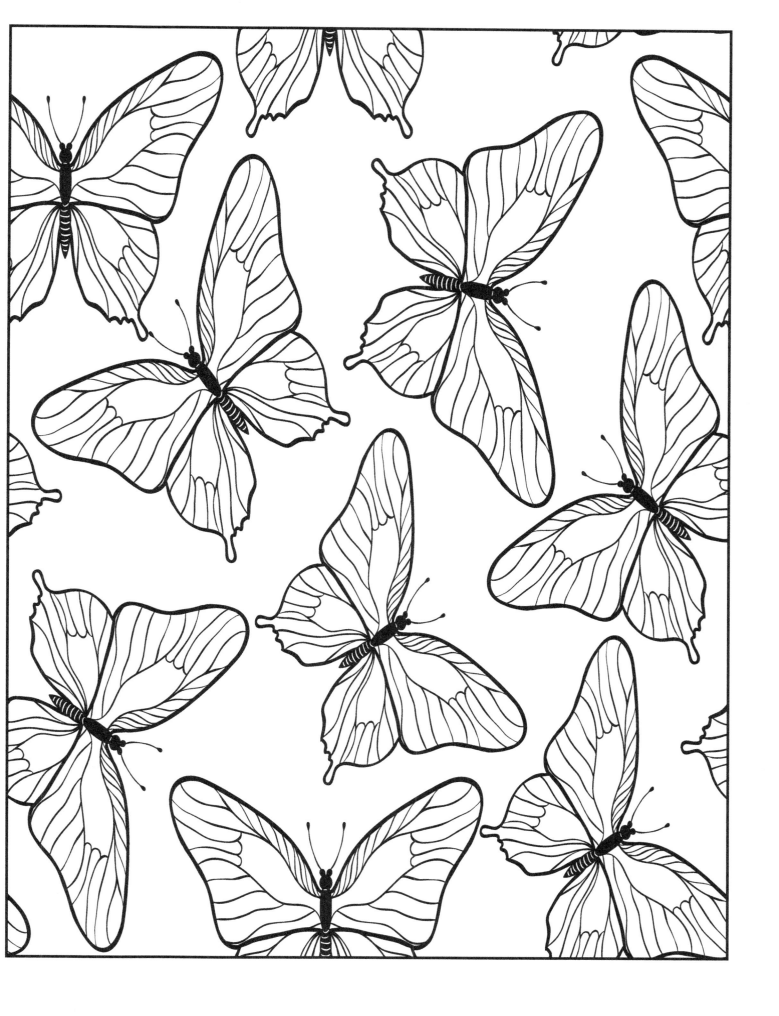

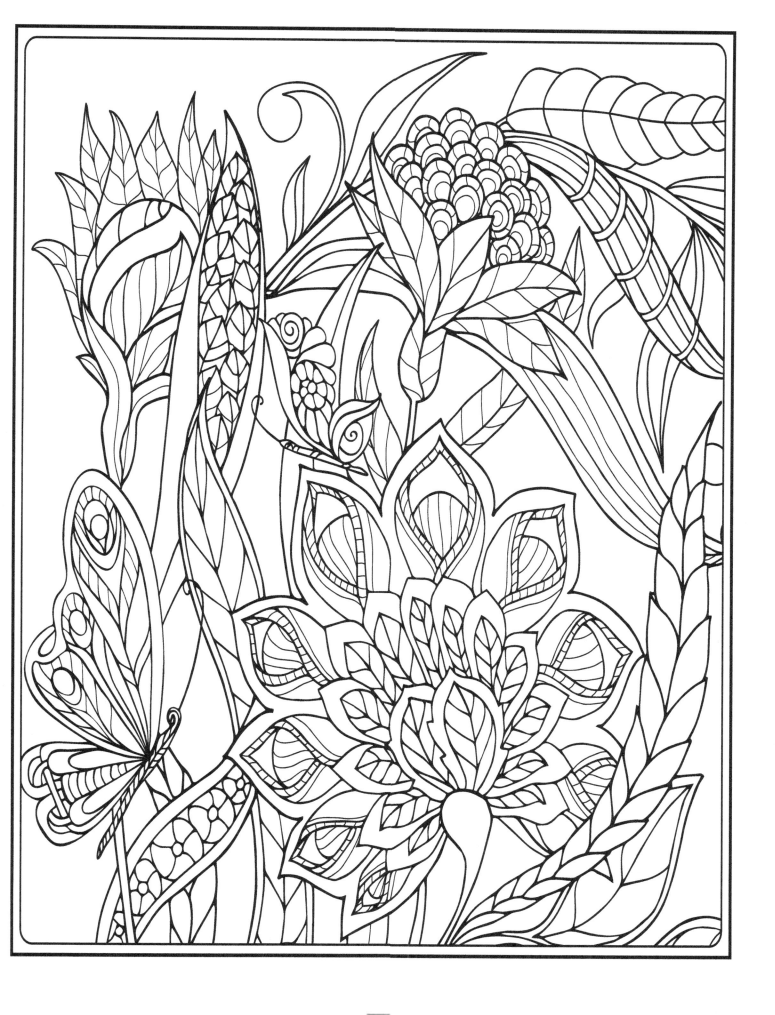

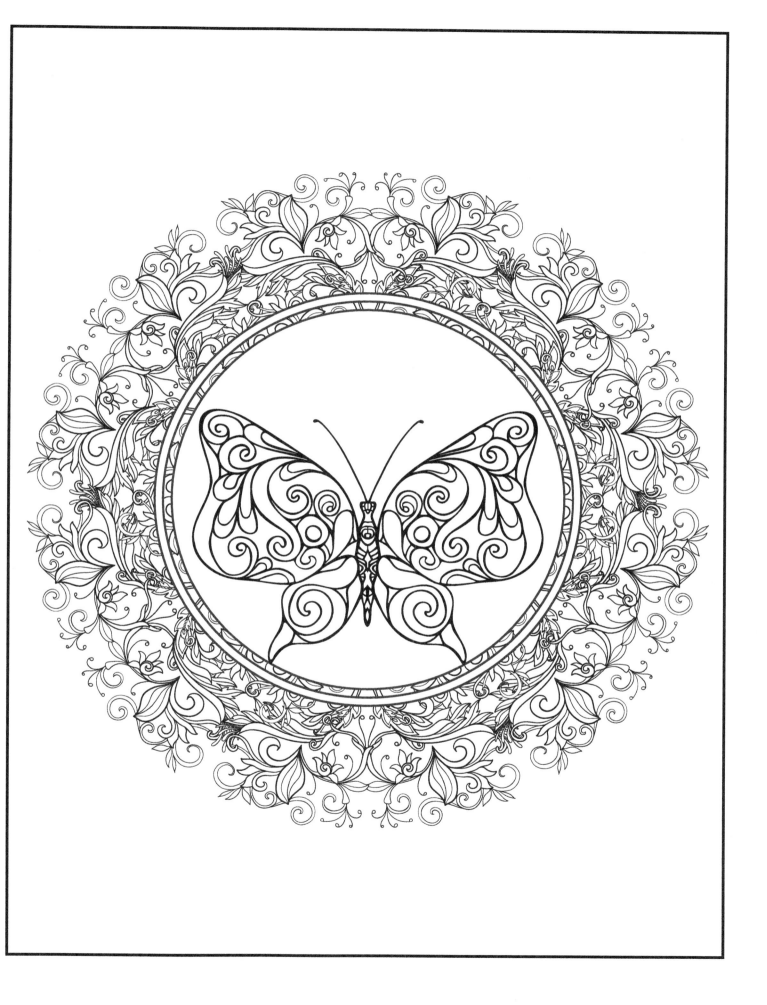

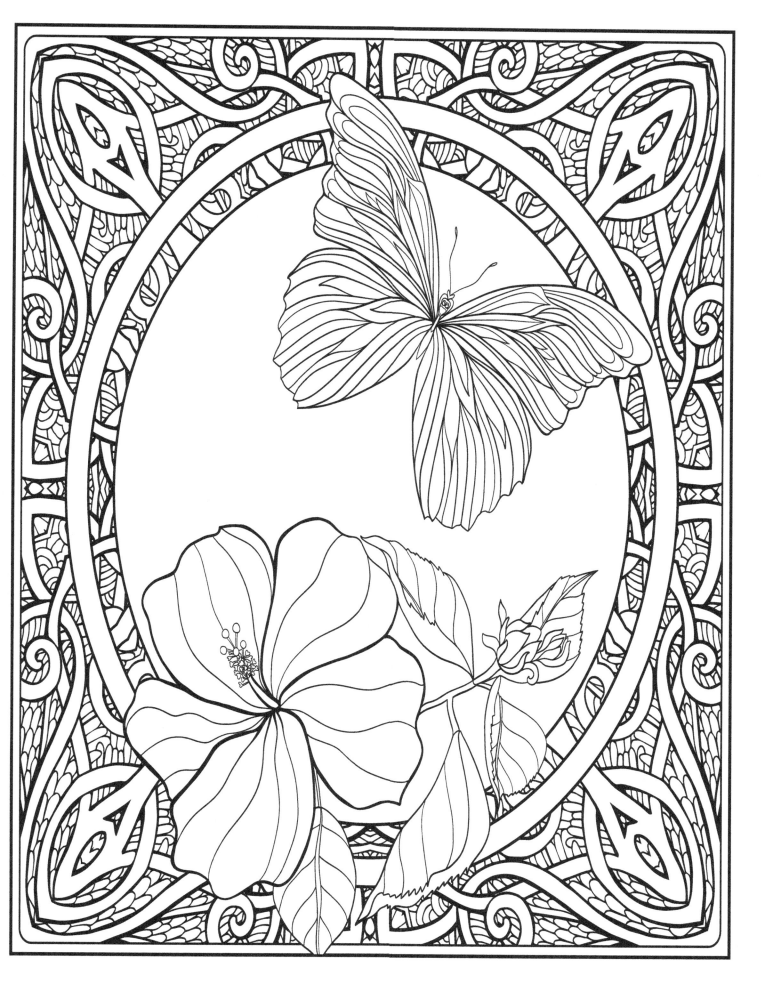

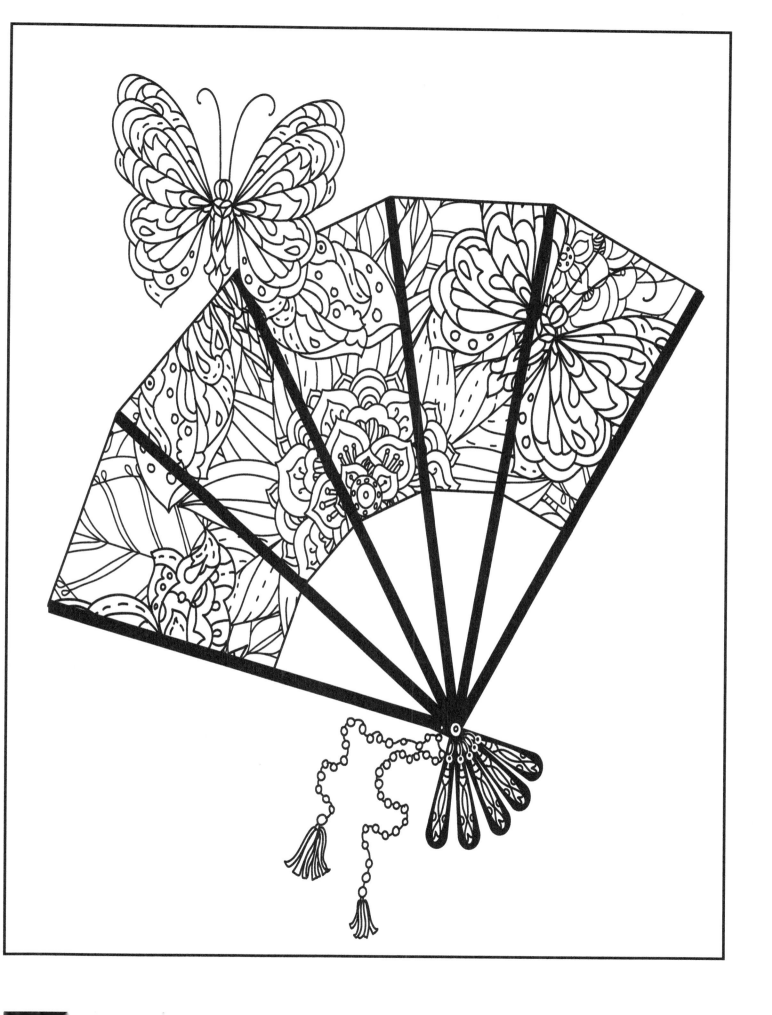

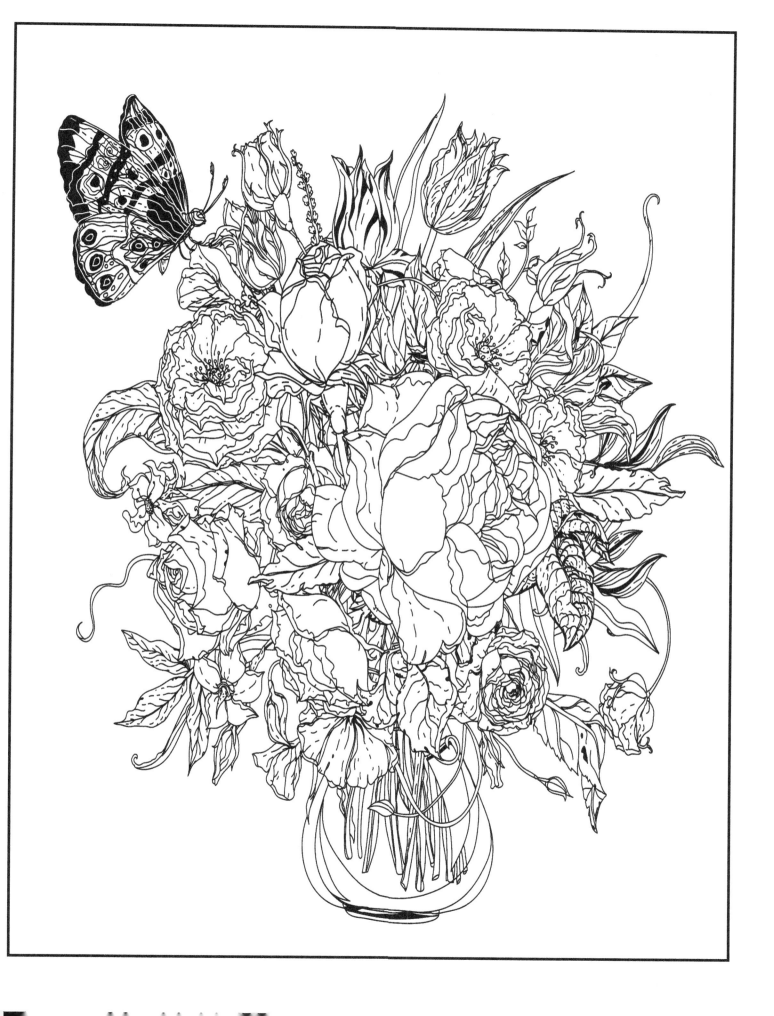

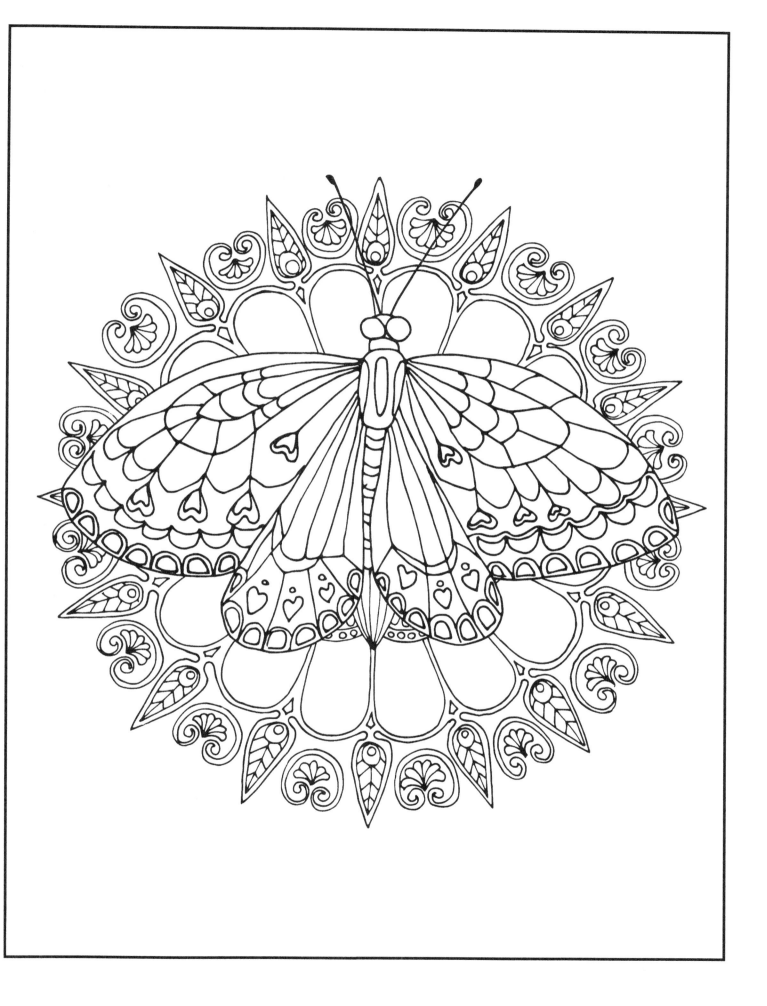

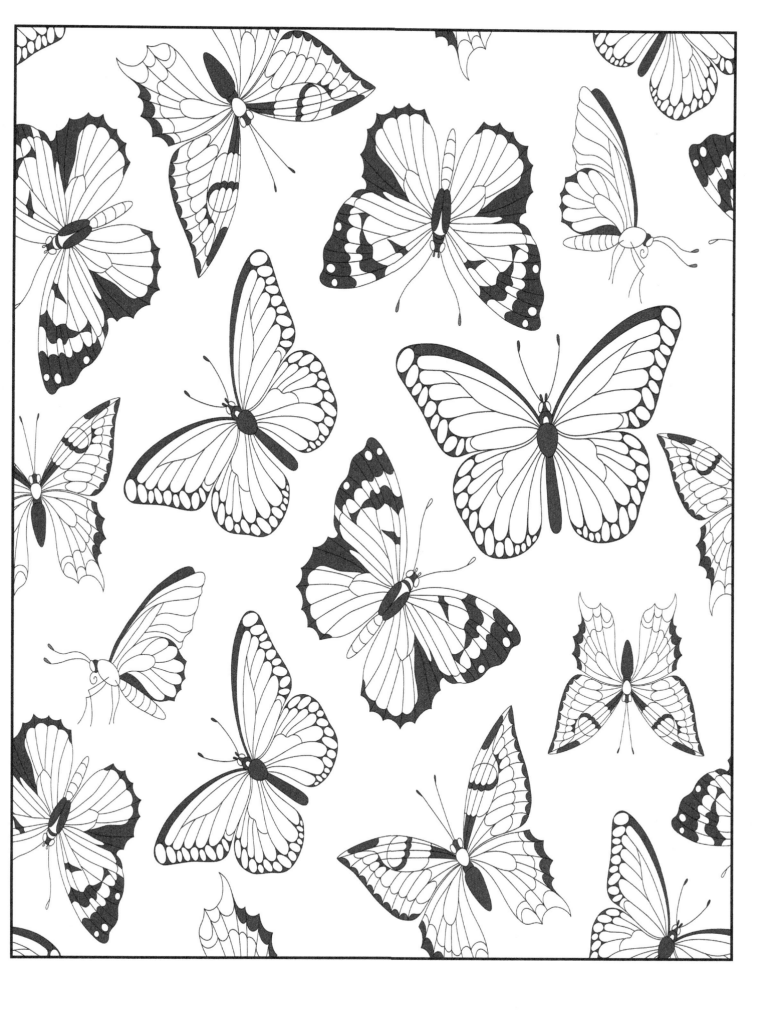

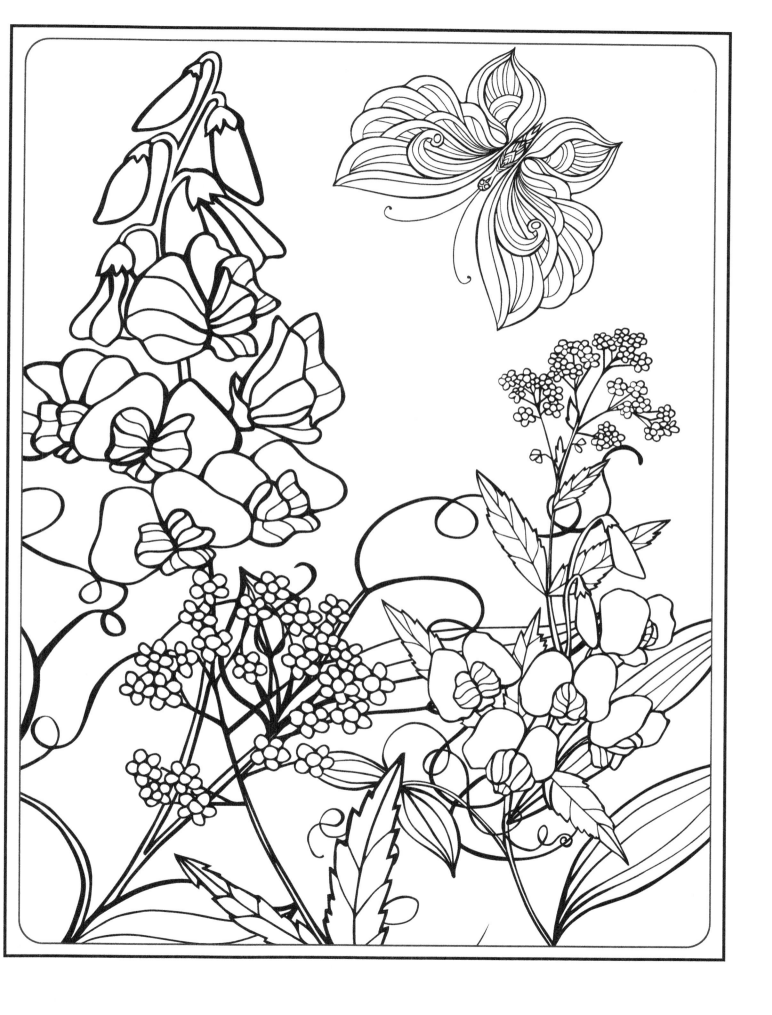

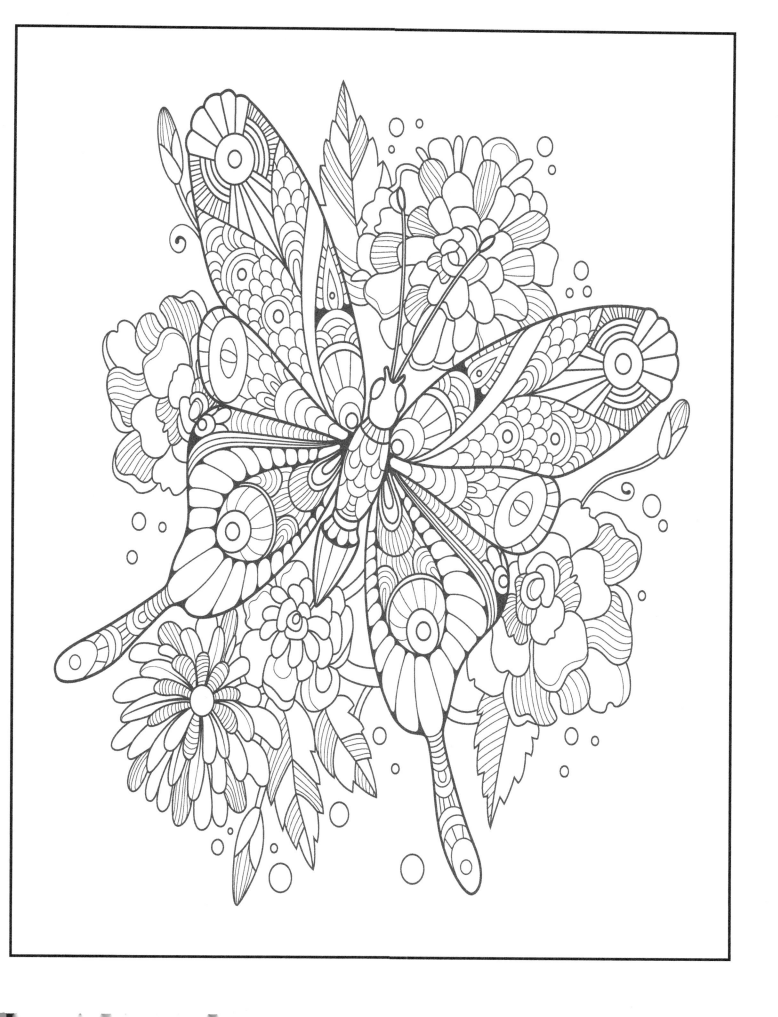

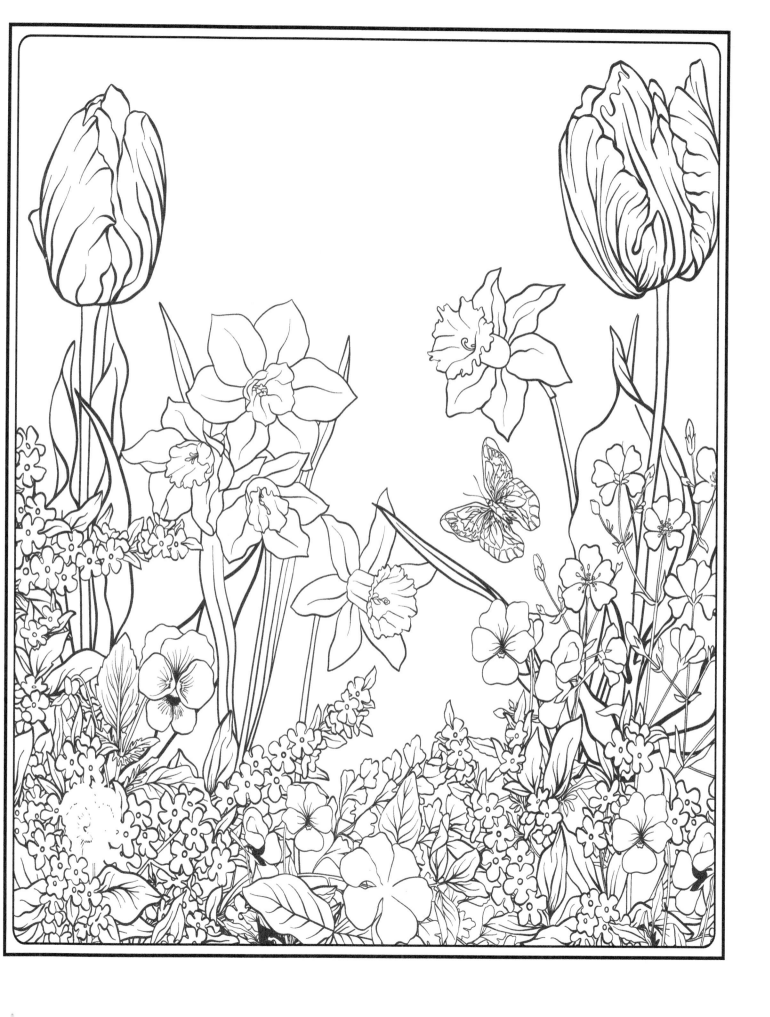

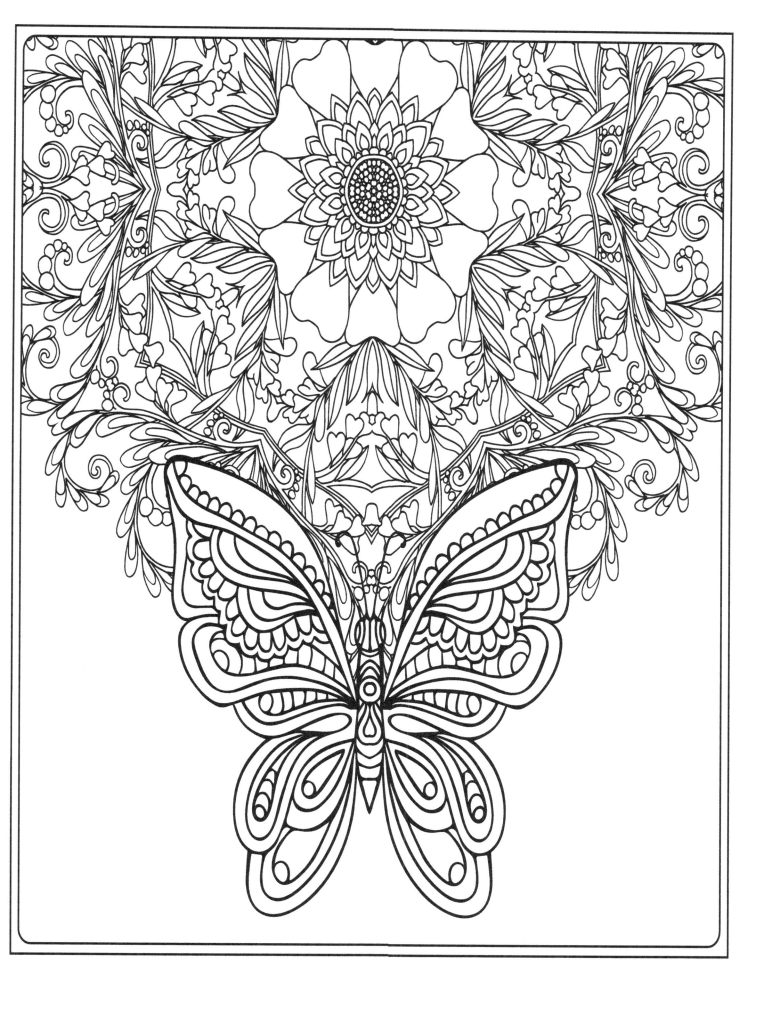

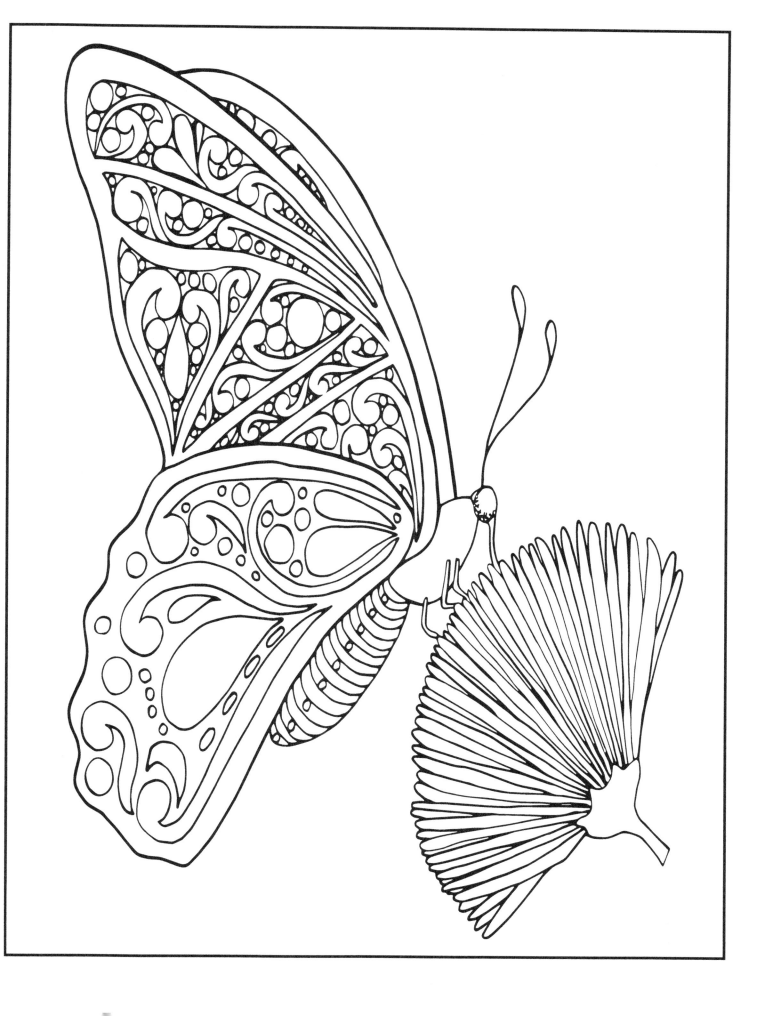

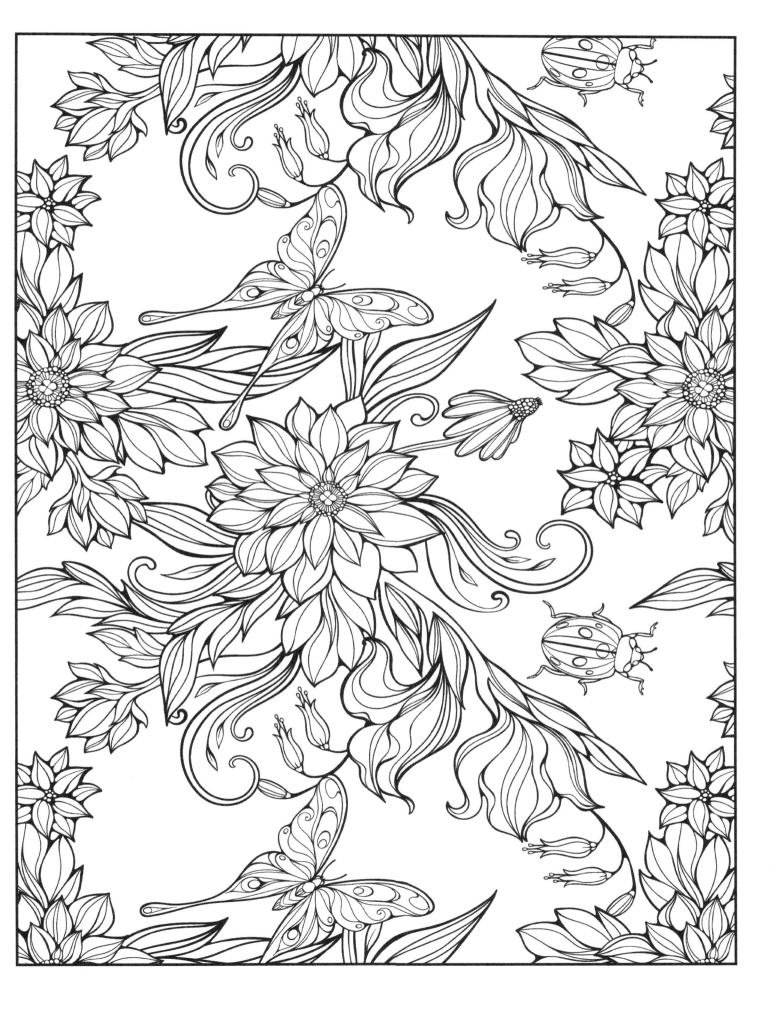

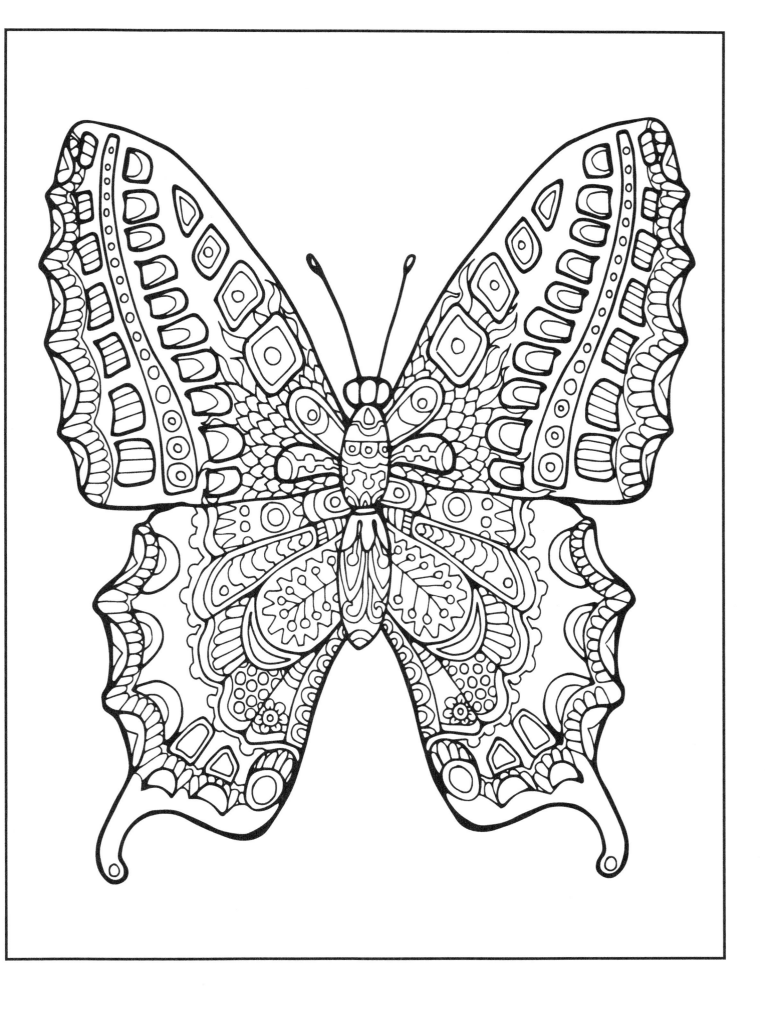

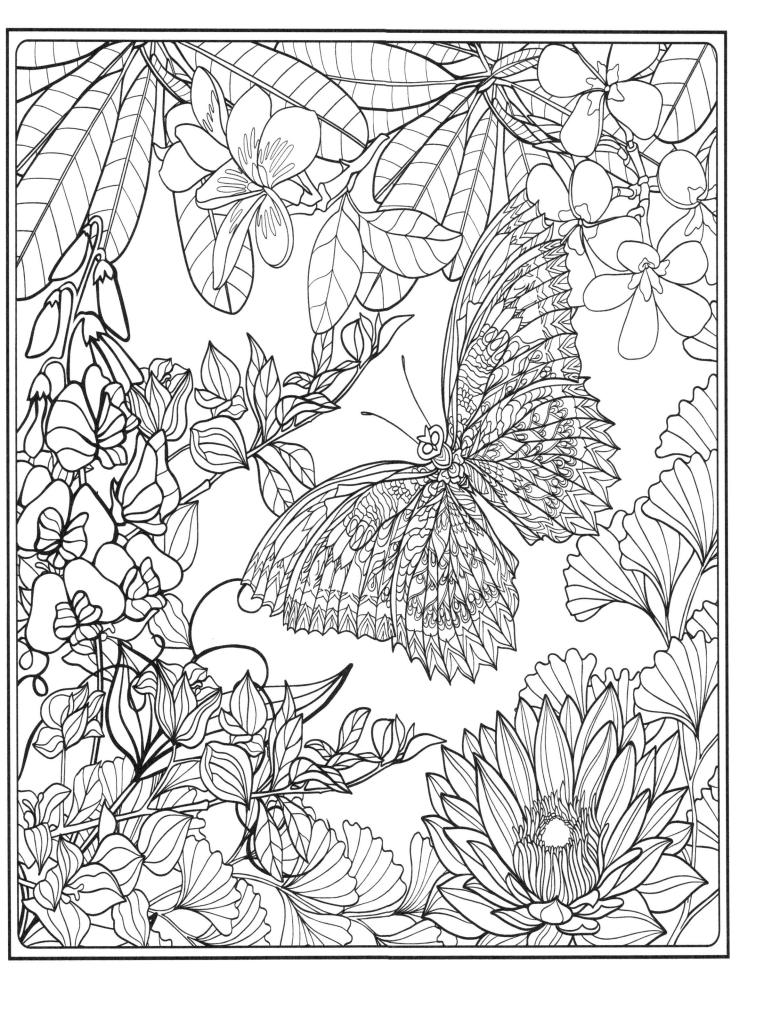

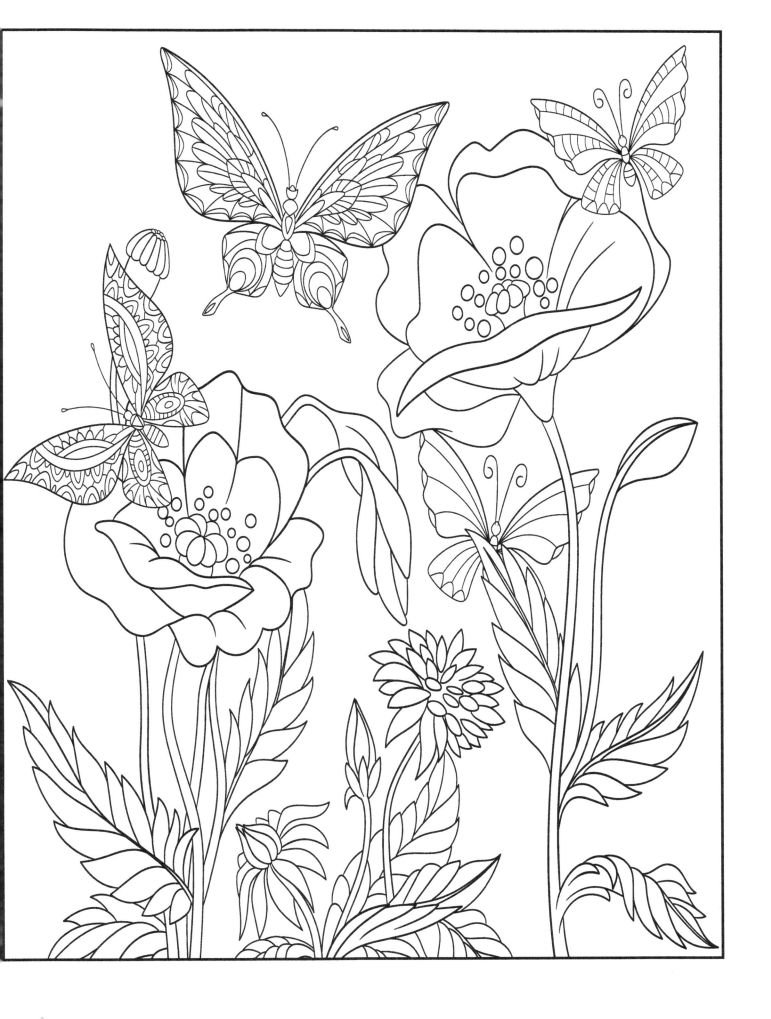

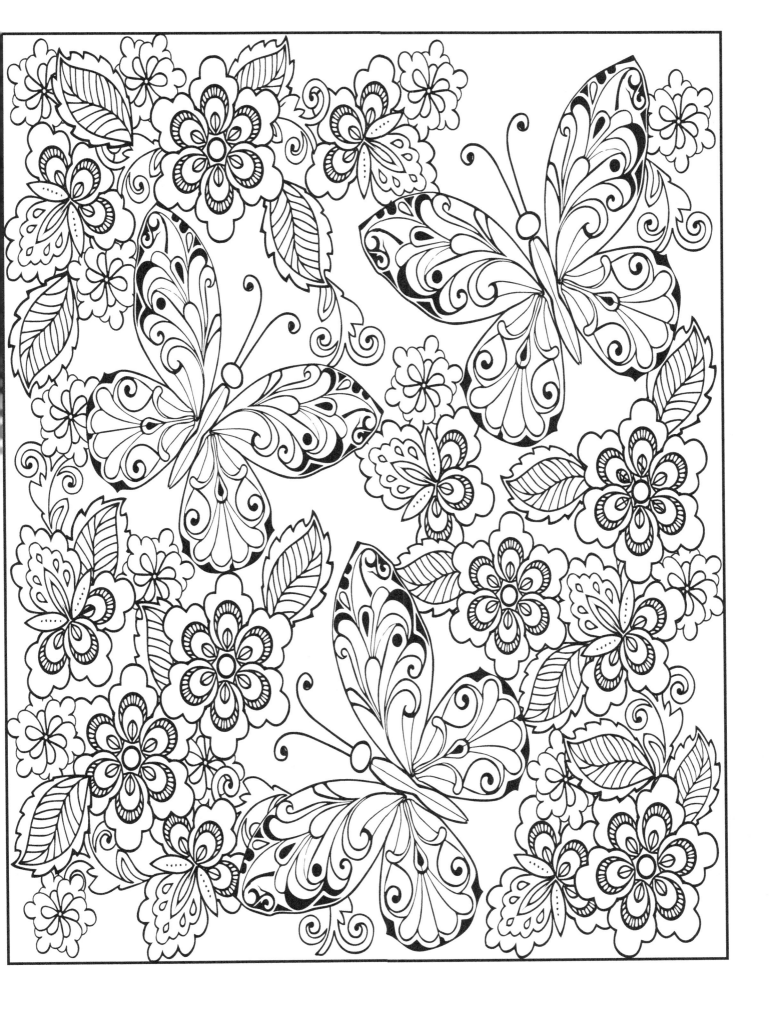

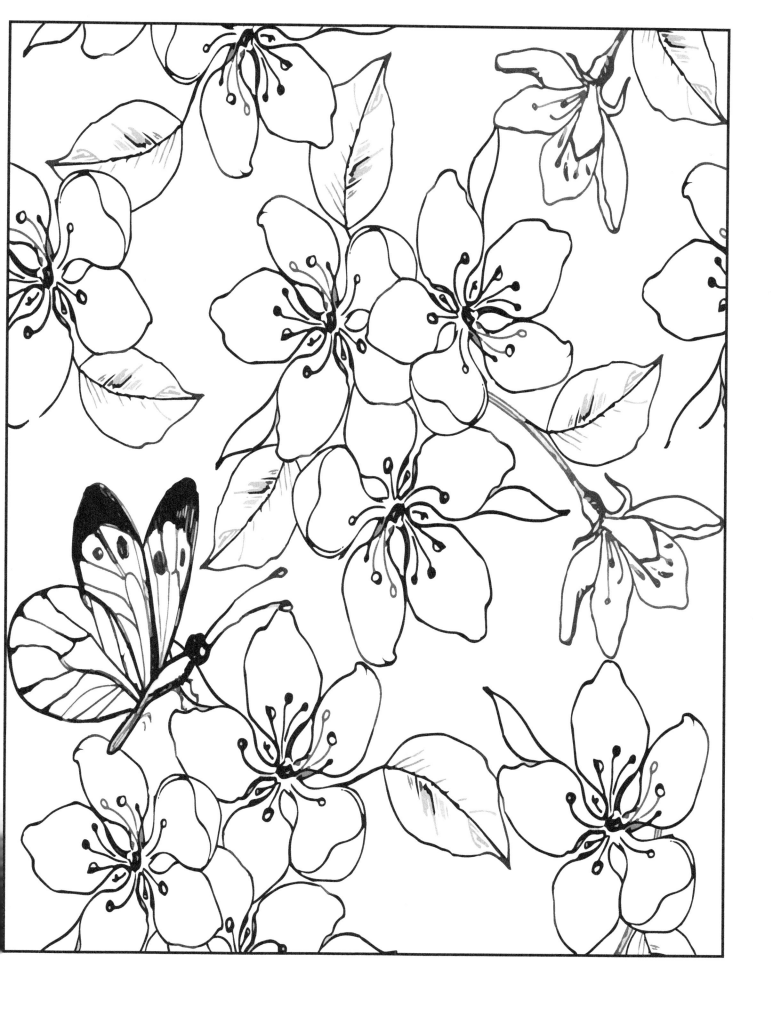

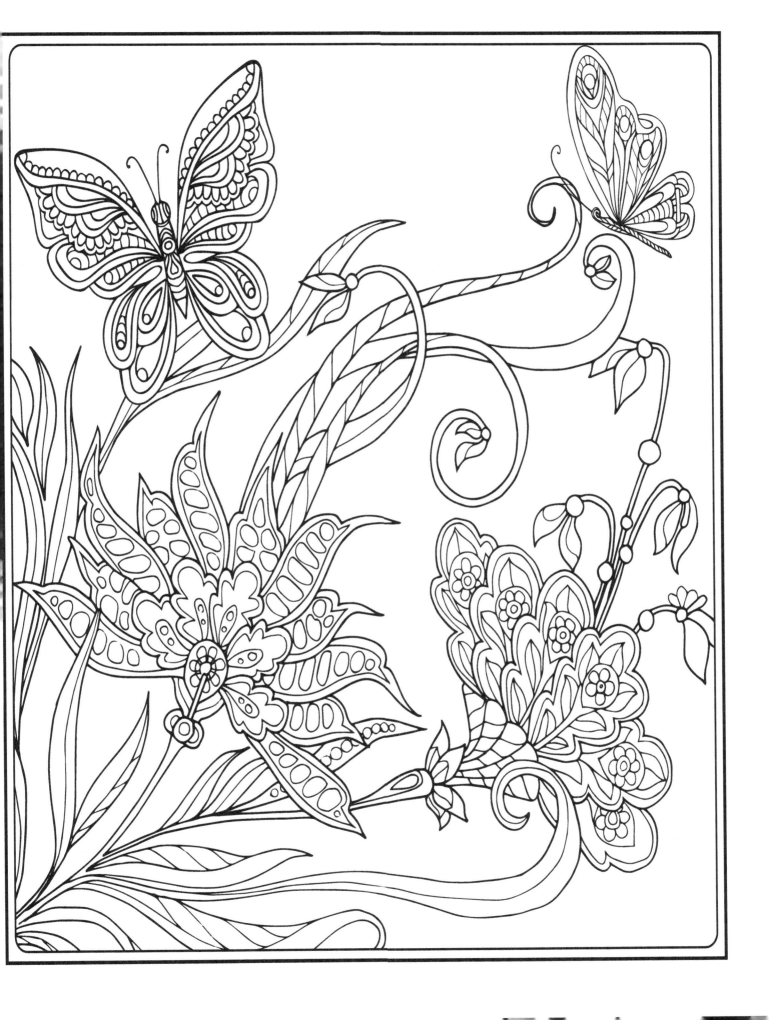

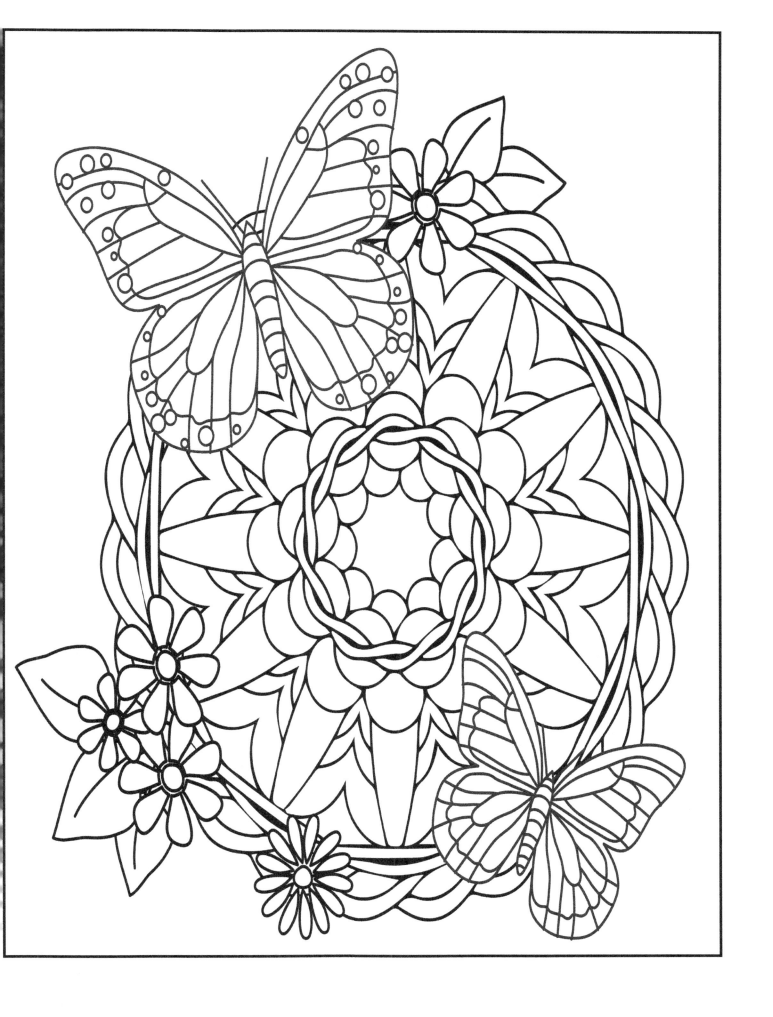

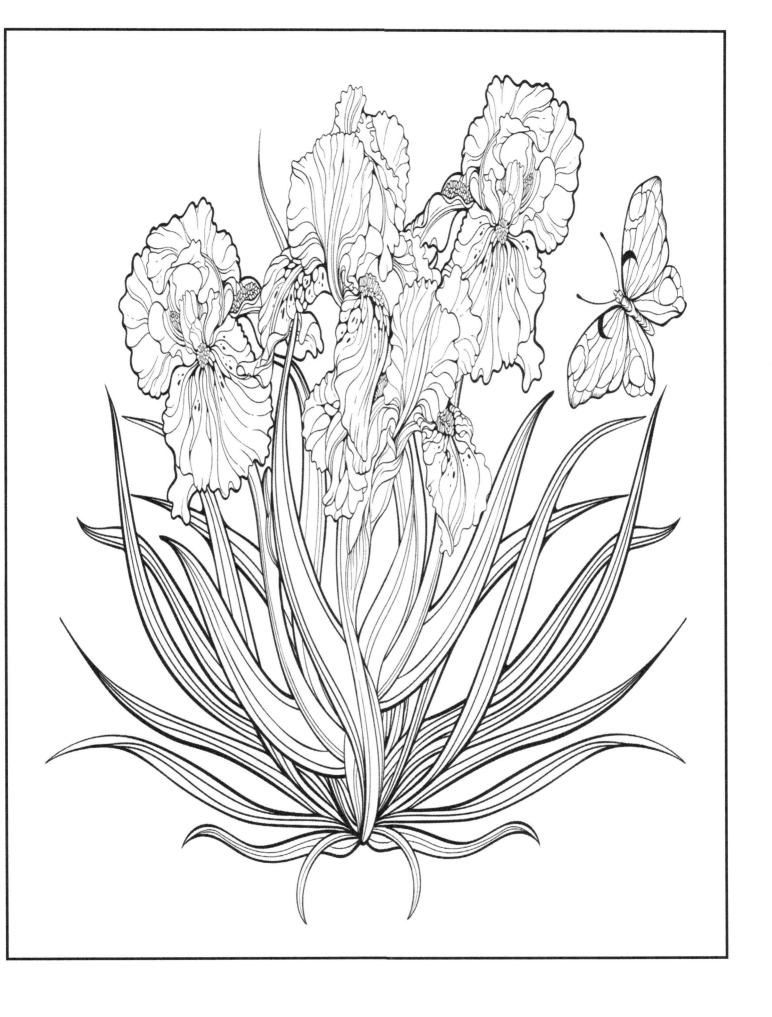

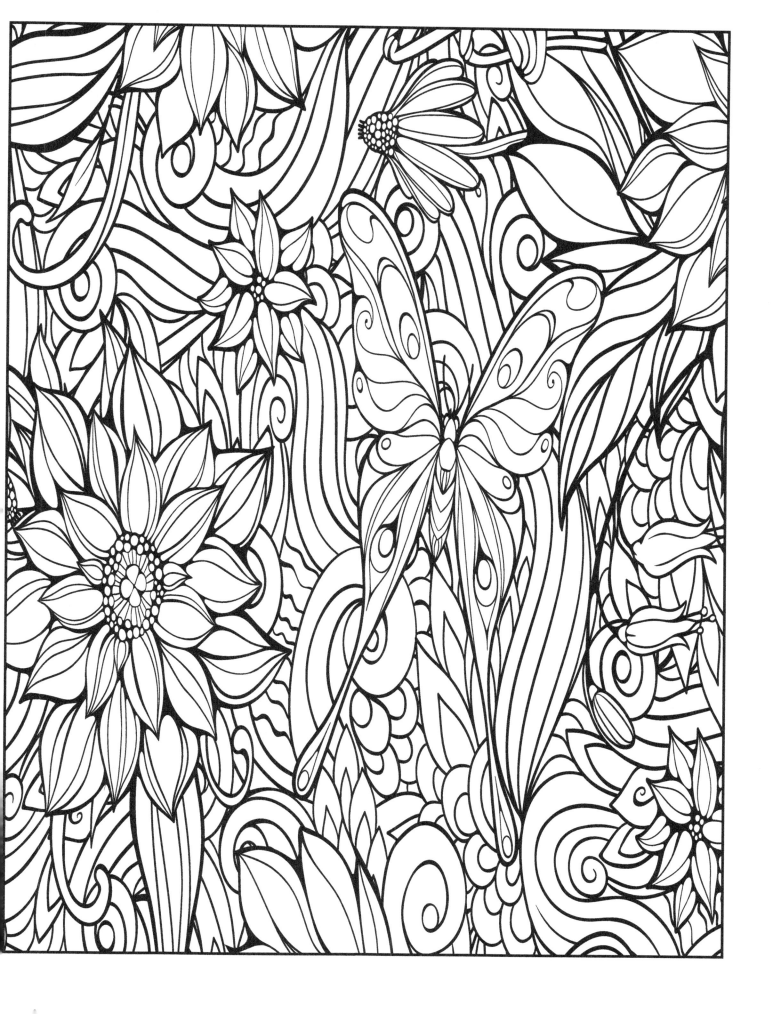

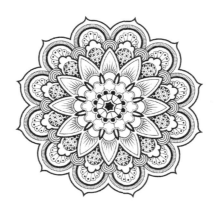

Thank you!

If you enjoyed this book, please take a moment to share your thoughts and post a positive review with a 5 star rating on Amazon. We will be deeply grateful for your help! Amazon makes it easy to post comments and share pictures of your completed pages for the world to see.

Our mission of helping to fund art education for students in public schools depends on our ability to sell adult coloring books. We welcome your suggestions! Learn more about what we are doing on our website, where we also have free designs for you to download, and tips about coloring techniques.

For free coloring designs to download and print for your own use, please go to: www.ArtandColorPress.com/free-downloads

Please help us spread the word!
Put a review on Amazon. Tell your friends.
Give coloring books as gifts.

www.ArtandColorPress.com

CPSIA information can be obtained
at www.ICGtesting.com
Printed in the USA
BVOW04s2025121117
500193BV00035B/363/P